PERSEPHONE

This book is a synthesis of dance, photography, and poetry—of kinetic energy, the documentary image, and the evocative use of words. In May 1994, photographer Philip Trager and I began a reexamination of *Persephone*, a dance commissioned by Jacob's Pillow Dance Festival that I originally choreographed for the stage in 1991. As we reimagined the dance in a series of tableaux surrounded by the wild, spring nature of the Berkshires, this collaboration among choreographer, photographer, and dancers evolved in the presence of the mechanical and emotional perspective of the camera's lens. The result is a metamorphosis of what had been a live-performance experience into a new form of physically cinematic choreographed stills. Through this collaboration we discovered a new method derived from both our mediums. The addition of inspired poems by Eavan Boland and Rita Dove brings to this work the focus of language, the energy of sounds, many possible interpretations and the continued exploration of the possibilities that reside within the intersections of disparate art forms.

For a moment in this experiment we share with you a collaborative anatomy—many as one.

—*Ralph Lemon*

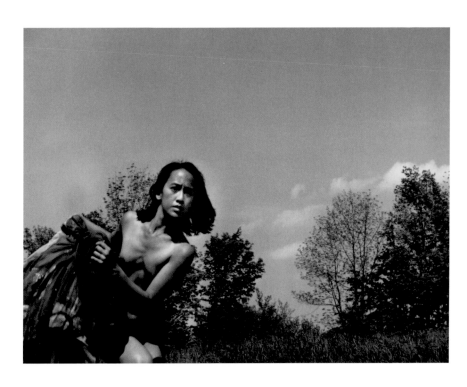

PERSEPHONE

PHILIP TRAGER
RALPH LEMON

with poems by Eavan Boland and Rita Dove
text by Ralph Lemon and Andrew Szegedy-Maszak

Wesleyan University Press
with
The New England Foundation for the Arts

Distributed by
University Press of New England
Hanover and London

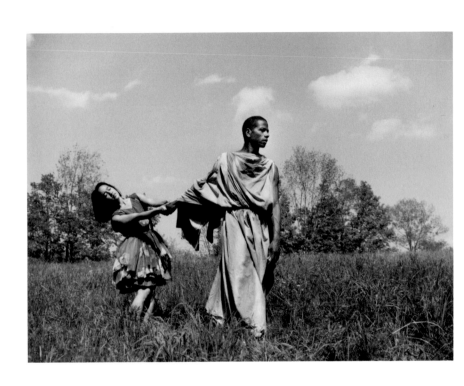

Demeter, goddess of harvest, had a daughter, Persephone, who embodied the innocence of spring. Hades, the lonely god of the underworld, saw Persephone picking his heart-sprung narcissus and, with a love not of this earth, he bore her off, her young screams echoing up into a quickly vanishing world. Hades carried Persephone down to his dark paradise, where he made her his bride. He gave her a queen's throne and took away her life as the unmarked girlchild who had played in fields of iris and golden alexanders. Thus Demeter lost Persephone and, in her awful wailing, made the earth barren and refused life's fruits to its mortal inhabitants. Demeter's tears turned to ice and a bargain was struck between god and goddess: Persephone would be allowed to rise from the underworld every spring to rejoin her mother, but she would bring with her the shadows of where she had been and the knowledge that she must return to her dark kingdom at the advent of winter.

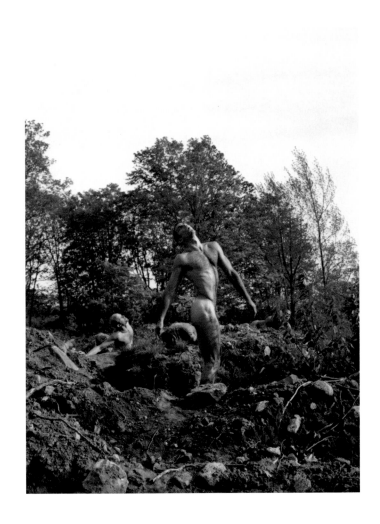

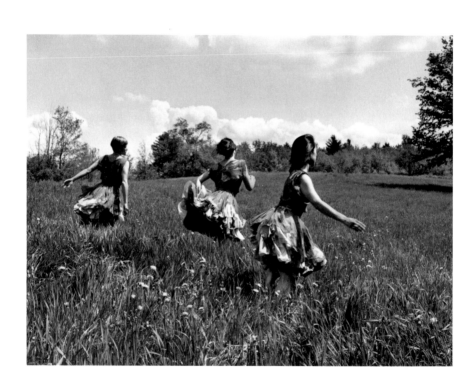

The Narcissus Flower

I remember my foot in its frivolous slipper,
a frightened bird . . . not the earth unzipped

but the way I could see my own fingers and hear
myself scream as the blossom incinerated.

And though nothing could chasten
the plunge, this man
adamant as a knife easing into

the humblest crevice, I found myself at
the center of a calm so pure, it was hate.

The mystery is, you can eat fear
before fear eats you,

you can live beyond dying—
and become a queen
whom nothing surprises.

—*Rita Dove*

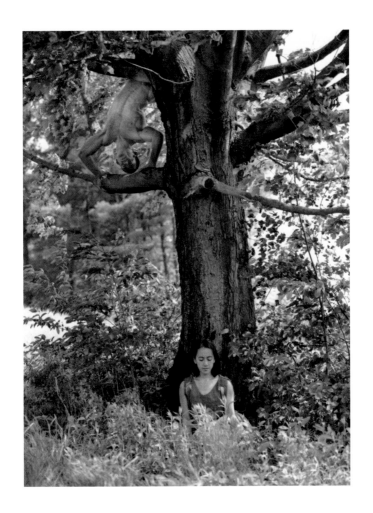

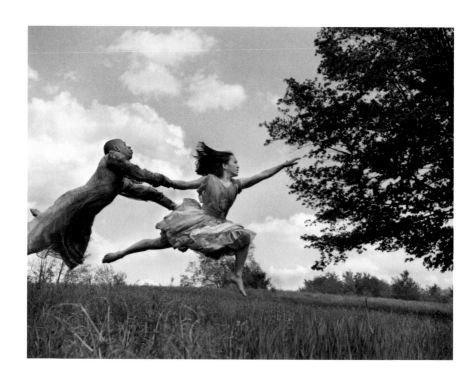

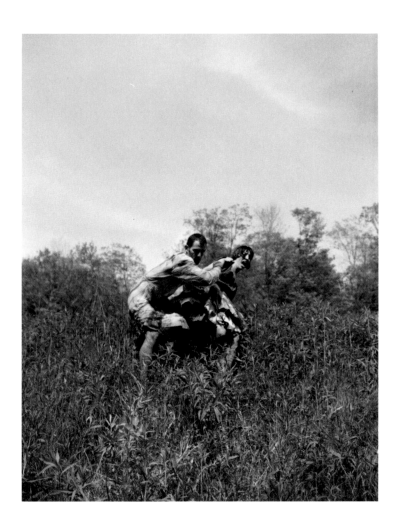

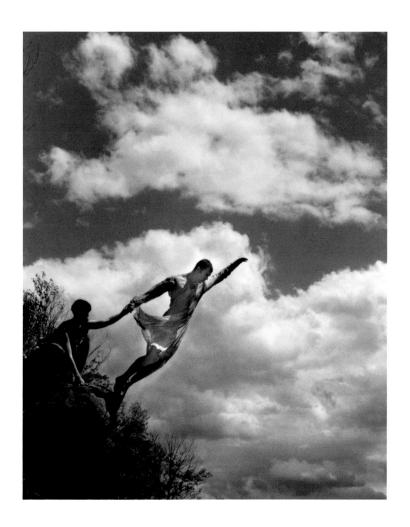

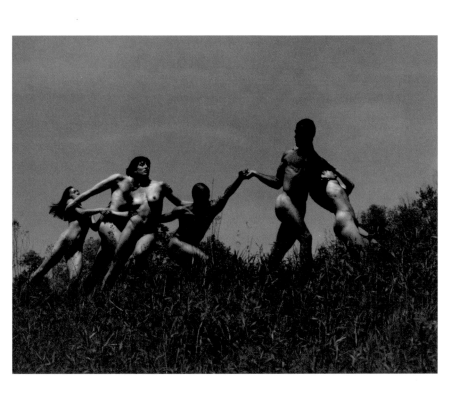

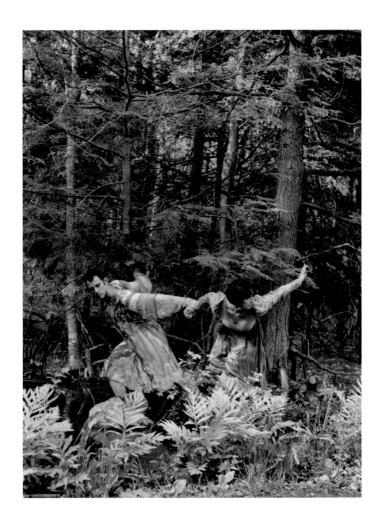

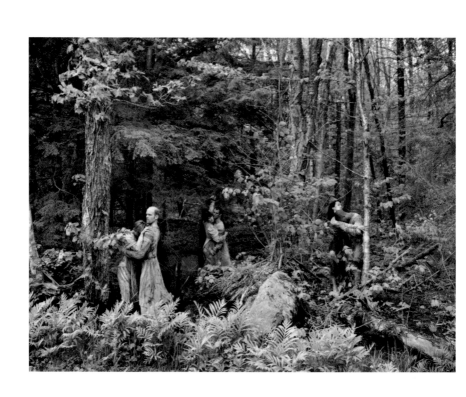

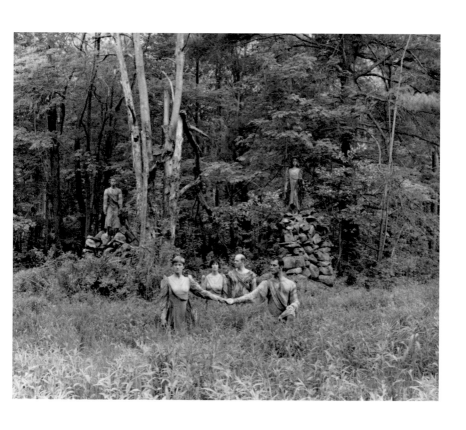

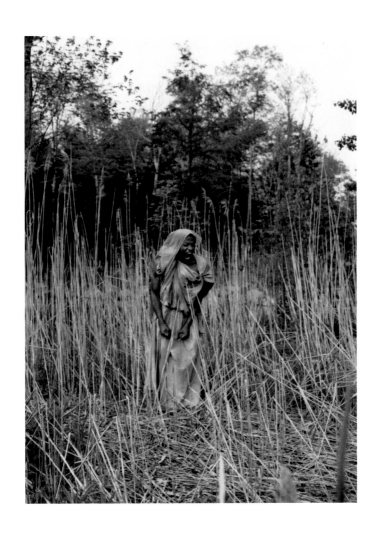

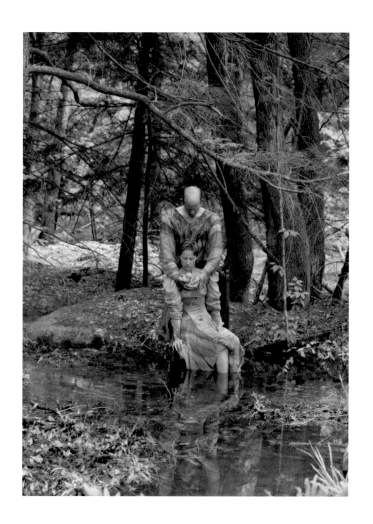

The Pomegranate

The only legend I have ever loved is
The story of a daughter lost in hell.
And found and rescued there.
Love and blackmail are the gist of it.
Ceres and Persephone the names.
And the best thing about the legend is
I can enter it anywhere. And have.
As a child in exile in
A city of fogs and strange consonants,
I read it first and at first I was
An exiled child in the crackling dusk of
The underworld, the stars blighted. Later
I walked out in a summer twilight
Searching for my daughter at bedtime.
When she came running I was ready
To make any bargain to keep her.
I carried her back past whitebeams.
And wasps and honey-scented buddleias.
But I was Ceres then and I knew
Winter was in store for every leaf
On every tree on that road.
Was inescapable for each one we passed.
And for me.
It is winter
And the stars are hidden.
I climb the stairs and stand where I can see
My child asleep beside her teen magazines,
Her can of Coke, her plate of uncut fruit.

The pomegranate! How did I forget it?
She could have come home and been safe
And ended the story and all
Our heartbroken searching but she reached
Out a hand and plucked a pomegranate.
She put out her hand and pulled down
The French sound for apple and
The noise of stone and the proof
That even in the place of death,
At the heart of legend, in the midst
Of rocks full of unshed tears
Ready to be diamonds by the time
The story was told, a child can be
Hungry. I could warn her. There is still a chance.
The rain is cold. The road is flint-coloured.
The suburb has cars and cable television.
The veiled stars are above ground.
It is another world. But what else
Can a mother give her daughter but such
Beautiful rifts in time?
If I defer the grief I will diminish the gift.
The legend must be hers as well as mine.
She will enter it. As I have.
She will wake up. She will hold
The papery, flushed skin in her hand.
And to her lips. I will say nothing.

—Eavan Boland

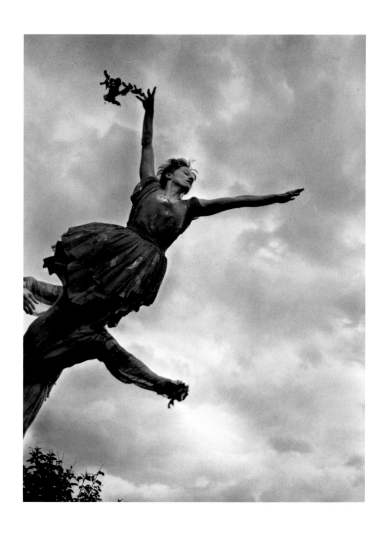

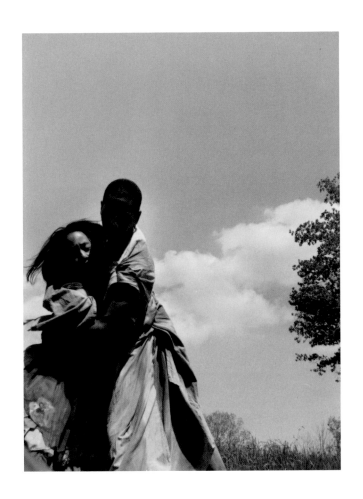

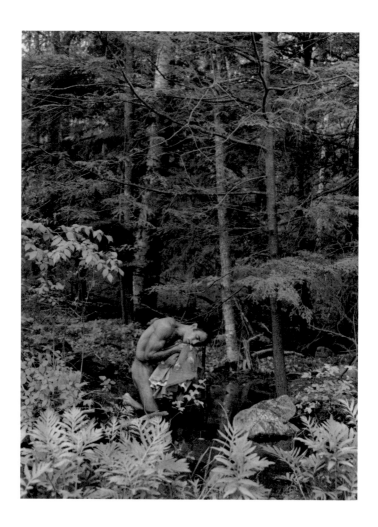

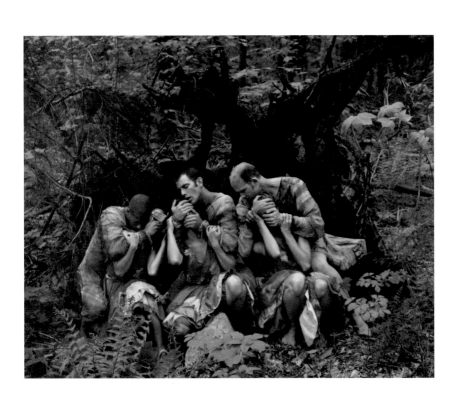

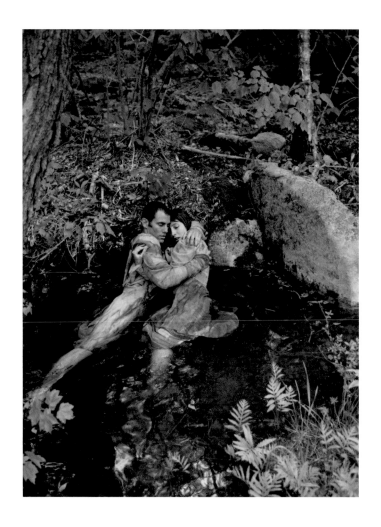

Demeter and Persephone

Fearsome myths are gifts
that call men to the worship of the gods.

So proclaims the chorus in Euripides' tragedy *Electra*. Fearsome, awesome, awe-inspiring—*phoberos* in ancient Greek—perfectly describe the myth of Demeter and Persephone. It touches on themes that evoked, and can still evoke, powerful responses. Even a cursory outline conveys some of the story's intensity, for it includes: a violent assault on a youthful, innocent maiden—a scene made all the more poignant by its setting in an idyllic meadow of wildflowers [page 10]; the anguished wandering of the mother searching for her child [25]; extensive human suffering brought about by a dispute among the gods; a deceptive gift, in the form of a pomegranate that Hades offers to Persephone [27]; and, finally, the reunion of mother and daughter [33], joyful, to be sure, but partial and contingent.

Underlying the whole tale are the fundamental rhythms of the seasons, the land's ageless cycle of barrenness and regeneration. So long as Demeter is furious and sorrowful, the crops wither, harvests fail, and humans starve. The myth also incorporates the deep truth that all happiness carries within itself the inescapable specter of loss. The fruit Persephone tasted acts as a kind of magical charm, binding her to the underworld. The embrace of Demeter and Persephone signifies the successful end of Demeter's quest and the return of fertility to the earth, but it takes place shadowed by the certainty that Persephone must return to Hades again.

Demeter was worshipped throughout the Greek world as the patron of the harvest and abundance of all kinds. She received special veneration from the Athenians, who reenacted her myth every year in the form of a solemn ritual.

We know they performed sacrifices and marched in a grand procession to Demeter's sanctuary at Eleusis, some thirteen miles distant from the city. Their journey, which replicated the goddess's own wanderings, served as the preparation for entry into the shrine itself. At that point, the Eleusinian Mysteries, as they have come to be known, become fully mysterious for us. It seems certain that the initiates underwent a symbolic passage from plenty, through sadness and deprivation, to a vision of the deity and a blissful celebration. The details of their experience, however, remain hidden. Over the centuries, tens of thousands of Athenians must have taken part in the rites of the goddess, yet no one ever broke the sacred silence that protected these holy events from the curiosity of the uninitiated.

While preserving the basic elements of the venerable story, Ralph Lemon has transformed it into a contemporary ritual, with new reserves of mystery and wonder. Philip Trager, in turn, has created a sequence of remarkable photographic images. In his pictures, the dance is removed from a modern stage and reestablished in the natural world, under an open sky, in fields, crags, and groves. These still photographs pulse with motion and activity, in which all the characters are vividly present. Trager and Lemon have collaborated, in the fullest sense of the term, to bring the ancient story back to life. They remind us that, even in our skeptical age, great myths are gifts, if only we know how to use them.

—Andrew Szegedy-Maszak
Wesleyan University
March 1996

Acknowledgments

The photographs for this book were commissioned by Jacob's Pillow Dance Festival's Dance Anthology Project, from which the idea for this collaboration among photographer, choreographer, and dancers first arose.

The authors extend deepest thanks and sincere appreciation to Karen Brosius, Marilynn Donini, Stephanie French, and Jennifer Goodale at Philip Morris Companies Inc., whose early support helped make this book possible. For their passion and generosity in support of this work, we thank Sam Miller of the New England Foundation for the Arts; Holly Sidford; Joan Duddy, Brighde Mullins, and Michael Govan at the Dia Center for the Arts; Ann Rosenthal at MAPP; Bill Yehle, Alexandra Heddinger, and the staff of Jacob's Pillow Dance Festival; Peter Blaiwas and Brian Hotchkiss of Vernon Press; and Ina Trager. We are especially grateful to the writers whose contributions have enhanced this book: to Eavan Boland and Rita Dove for granting permission to reprint their poems, and to Andrew Szegedy-Maszak for writing an essay especially for this volume. We are grateful to Katherine Maurer, costume designer for *Persephone*, and, of course, to Wally Cardona, Barbara Grubel, Alissa Hsu, Ted Johnson, Nicholas Leichter, and Lisa Powers, the dancers who recreated the dance for the photographs in this book.

Printing courtesy of Philip Morris Companies Inc., and the New England Foundation for the Arts with support from the National Endowment for the Arts.

Designed by Peter M. Blaiwas, Vernon Press, Inc.
Printed at Van Dyck Columbia Press, North Haven, Connecticut

ISBN 0-8195-5303-4
Library of Congress catalog card number 96-068503

Distributed by University Press of New England
23 South Main Street, Hanover, NH 03755–2048

Printed in the United States of America
First edition